MOCTEZUMA
AND THE AZTECS

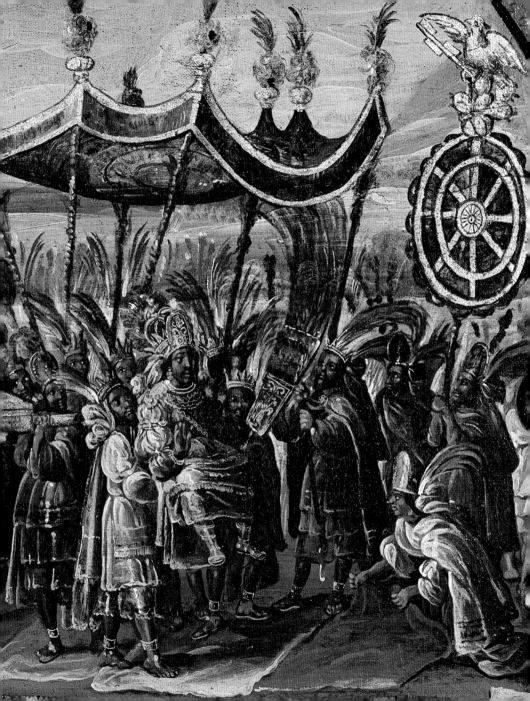

MOCTEZUMA
AND THE AZTECS

Elisenda Vila Llonch

THE BRITISH MUSEUM PRESS

© 2009 The Trustees of the British Museum

Elisenda Vila Llonch has asserted the right to be identified as the author of this work

First published in 2009 by
The British Museum Press
A division of The British Museum Company Ltd
38 Russell Square, London WC1B 3QQ

www.britishmuseum.org

A catalogue record for this book is available from the British Library

ISBN 978-0-7141-2589-3

Designed by Price Watkins
Printed in Italy

Half-title: Detail of the Codex Mendoza (fol. 15v) showing Moctezuma and his name glyph.
Frontispiece: Moctezuma and his retinue prepare to meet Cortés.

Papers used by The British Museum Press are
natural, recyclable products made from wood
grown in sustainable forests. The manufac-
turing processes conform to the environmental
regulations of the country of origin.

Mixed Sources

Product group from well-managed
forests and other controlled sources
www.fsc.org Cert no. CQ-COC-000012
© 1996 Forest Stewardship Council

Contents

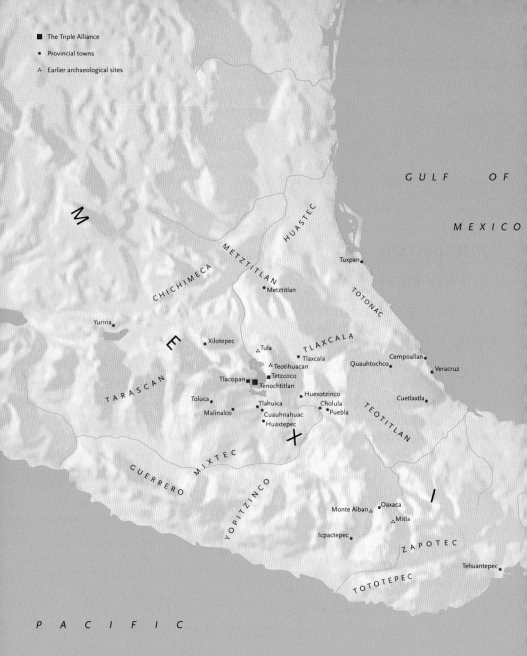

GULF OF

MEXICO

M

HUASTEC

METZTITLAN

CHICHIMECA

Tuxpan

Metztitlan

TOTONAC

Yuriria

E

Xilotepec

Tula

Teotihuacan

TLAXCALA

Tlaxcala

Quauhtochco

Cempoallan

Veracruz

Tlacopan

Tetzcoco

Tenochtitlan

Huexotzinco

Cuetlaxtla

TARASCAN

Toluca

Tlahuica

Cholula

Malinalco

Cuauhnahuac

Puebla

TEOTITLAN

Huaxtepec

X

GUERRERO

MIXTEC

Monte Alban

Oaxaca

I

Mitla

YOPITZINCO

Icpactepec

ZAPOTEC

Tehuantepec

TOTOTEPEC

PACIFIC

OCEAN

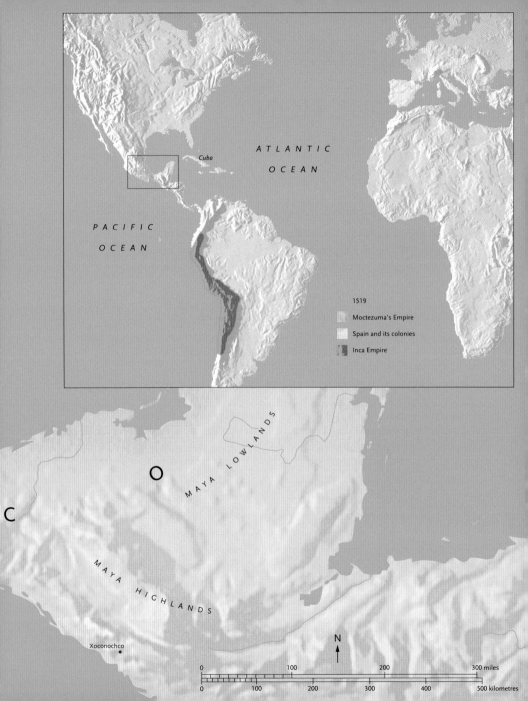

ATLANTIC OCEAN

Cuba

PACIFIC OCEAN

1519

Moctezuma's Empire

Spain and its colonies

Inca Empire

MAYA LOWLANDS

O

C

MAYA HIGHLANDS

Xoconochco

N

| 0 | | 100 | | 200 | | 300 miles |

| 0 | 100 | 200 | 300 | 400 | 500 kilometres |

INTRODUCTION

MOCTEZUMA II ruled at a pivotal moment in Mexican history. Between 1502 and 1520 he governed the most powerful and extensive empire ever known in Mesoamerica. However, his fate, and that of his people, was about to change with the arrival of the Spanish conquerors. Moctezuma would turn out to be the last elected Mexica ruler.

The stories of Moctezuma's deeds, his personality and charisma have only come down to us through partial historical accounts, both Spanish and indigenous, recorded after the conquest. Evidence of his power is also found in archaeological remains, while his royal persona can be glimpsed by decoding the symbolism carved in elaborate works of art. Moctezuma's fame has been reappraised through history to suit different political and ideological purposes. His name is forever associated with a great empire that ended tragically with the imposition of a new world order. Moctezuma's story may never be fully told, but parts of it can now be clarified when the written and the archaeological evidence are looked at together.

The Mexica, popularly but wrongly known as Aztecs, were a Nahuatl speaking group that migrated from the north and settled in the Basin of Mexico around the year AD 1200. As outsiders who would later demand tribute from the long-established communities around them they had to justify their actions under a divine mandate. They rewrote their history accordingly to fit their new agenda. Their humble origin, as a nomadic tribe that migrated from the north, was retold through a myth that placed their origin in seven caves located in a place called Aztlan, 'the white place'. This primordial place was a projection of their then monumental capital city Tenochtitlan, today Mexico City, which stood in Lake Tetzcoco.

An idealized view of Aztlan – the mythical place of origin of the Mexica – depicted in an island setting. Codex Aubin, fol. 3.

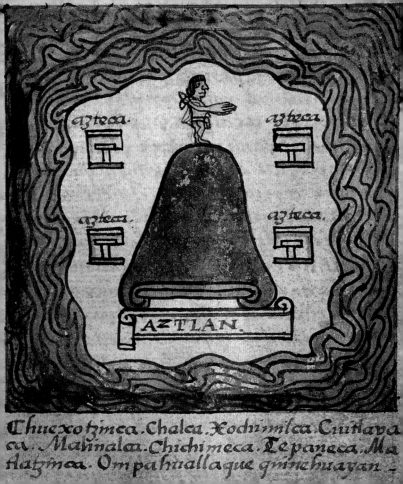

azteca. azteca. azteca. azteca.

AZTLAN.

Chuexotzinca. Chalca. Xochimilca. Cuitlaua
ca. Matlnalca. Chichimeca. Tepaneca. Ma
tlatzinca. Ompahuallaque quinehuayan.

The Mexica started their long migration led by their patron god Mexi or Huitzilopochtli. Divine instructions justified their actions from then on. Their wanderings through mythical and historical cities such as Tula and Coatepetl provided justification for linking their roots to ancient capitals and a splendid past. At the same time those places acted as a backdrop to mythical accounts that would be re-enacted, centuries later, in the ceremonial centre of their capital city Tenochtitlan to validate the history they had constructed and to ensure the indoctrination of the Mexica empire.

Their long journey through harsh lands was prophesied to end at the sight of a magnificent eagle, symbol of the sun, perched on a prickly pear cactus, eating the red fruits that resembled a human heart. That would be the place to build their mighty capital. The cactus had grown from the heart of Copil, the nephew of Huitzilopochtli, who had rebelled against the latter's edicts. Copil's heart was thrown into the lake and became a stone. This severed heart was a reminder to the world of the fate of Mexica enemies. Tenochtitlan was built on the blood of these enemies, who fed the power and strength of the city through war, conquest and sacrifices.

The chosen location, which would become the centre of the world following divine mandate, was an inhospitable marshy place, full of cacti and snakes. However, Mexica strength, their hard work and bravery in the battlefield allowed their growth and establishment in this new land. They built one of the most magnificent cities ever to exist in Mesoamerica, the large metropolis of Tenochtitlan.

Tenochtitlan became a fast-growing city that reached as many as 200,000 inhabitants by the time of Moctezuma's reign. It was built around a central ceremonial precinct with monumental temples devoted to the main deities, which rose over the city's skyline and the surrounding landscape. The religious precinct had adjacent markets, noble houses and palaces that served as the nerve centre for the empire's administrative and political affairs.

Divided into four symbolic parts and irrigated by canals, Tenochtitlan

Above
A carved greenstone
heart symbolizing
the sacrifices made by
the Mexica people.

Left
A naturalistic sculpture
of a cactus that was
probably used as a
boundary marker of the
city of Tenochtitlan.

12

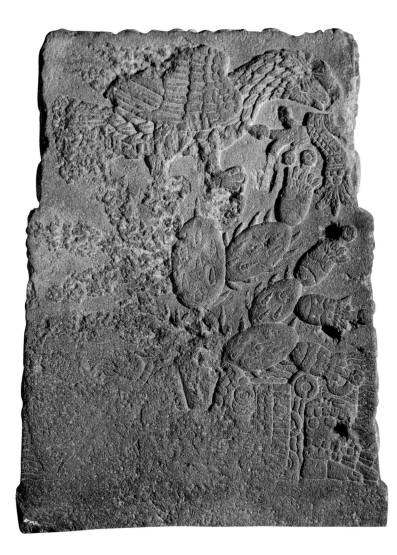

Left and opposite
The founding image of
Tenochtitlan carved on
the rear of the *Teocalli*
of Sacred Warfare (see
p. 72) and depicted
on the opening page
of the Codex Mendoza.
An eagle perches on a
cactus that grows from
the heart of Copil.

Opposite
The Codex Mendoza
shows a plan of
Tenochtitlan. The city
is set in the waters of
Lake Tetzcoco and
schematically divided
into four quarters by
criss-crossing canals.
Codex Mendoza, fol. 2r.

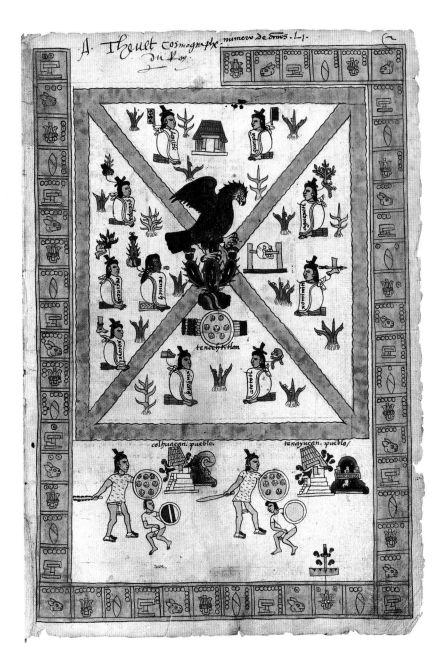

was made up of a number of neighbourhoods or *calpulli*. Each one had its own ceremonial precinct, administrative centre and market. Access to the city was carefully controlled by causeways, which had bridges that could be removed for protection. Canoe transportation was not only crucial around the lake and its shores, but allowed the flow of goods to the capital. *Chinampas*, or agricultural raised fields on the lake waters, supplied part of the food needed to sustain the large popula-tion. All kinds of products were taken daily to the bustling and well-ordered markets of the city, including exotic goods imported from distant provinces.

Tenochtitlan became the seat of power for Mexica rulers, and the base from which to extend their empire. The first ruler and founder of the city, Tenoch, was followed by a series of leaders, with the lineage of elected rulers traceable back to 1325. Within the royal family, the succession passed between fathers, grandfathers, uncles, brothers and cousins. Tenochtitlan achieved complete independence from Azcapotzalco under the rulership of Itzcoatl in 1430, creating the Triple Alliance (*excan tlatoloyan*) between the cities of Tenochtitlan, Tetzcoco and Tlacopan. From then on each ruling lord or *tlatoani* of Tenochti-tlan increased its wealth and territories, forging a complex network of tributary and strategic provinces.

Moctezuma was the ninth *tlatoani* ('he who speaks well'). He excelled in oratory, to communicate with the gods and to transmit the divine will to his people. His full name, Moctezuma Xocoyotzin, means 'He who Grows Angry [like a] Lord' 'the Venerable Youngest Son', com-monly known as 'the Younger'. He was a ruthless commander of his army and a strong political leader. As *huey tlatoani* (supreme ruler) he was regarded as a personification of the gods (*ixipltla*), and enjoyed semi-divine status with privileges above other mortals. People had to lower their heads in his presence, avoiding any direct contact with him, as one of the means to publicly reinforce his god-like status.

What Moctezuma really looked like remains elusive, as only a few stylized portraits of him have survived. One of the Spanish soldiers

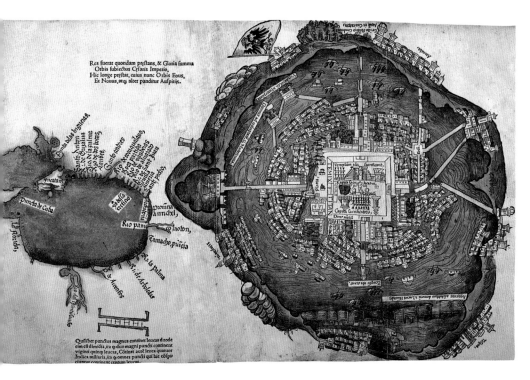

that met him, Bernal Díaz del Castillo, described him as being:

> ... of good height and well proportioned, slender and spare
> of flesh, not very swarthy, but of the natural colour and shade
> of an Indian. He did not wear his hair long, but so as just
> to cover his ears, his scanty black beard was well shaped and
> thin. His face was somewhat long but cheerful, and he had
> good eyes and showed in his appearance and manner both
> tenderness and when necessary, gravity.

Moctezuma's grandfather, Moctezuma Ilhuicamina ('He who

A map commissioned by
Cortés showing the Gulf
of Mexico on the left
and the Basin of Mexico
and Tenochtitlan on the
right. At the heart of
the city lies the enlarged
Sacred Precinct.

Detail from the colonial Codex Aubin. The white funerary bundle of Ahuitzotl, Moctezuma's predecessor, is depicted at the top along with his name glyph. Below, Moctezuma sits on his throne wearing the triangular turquoise diadem (crown) that identifies him as a ruler. Codex Aubin, fol. 40.

Pierces the Sky with an Arrow') (1440–69), was the longest ruling *tlatoani*. His son Axayacatl (1469–81), Moctezuma's father, inherited the throne, which in turn was passed successively to his two brothers, Tizoc (1481–86) and Ahuitzotl (1486–1502). Moctezuma was granted the royal insignias and became the new *tlatoani* after his uncle Ahuitzotl's death. Following the lavish and well-orchestrated funerary rites, which included the ritual burning of Ahuitzotl's funerary bundle and the burial of his ashes, Moctezuma was elected and came to power in all his full splendour.

A number of events would mark the reign of Moctezuma, but among them was one that would change the Mexica world forever. This was the arrival of the Spanish who, with their steel armours, horses and lust for gold showed no respect or understanding for the Mexica world order. Moctezuma was the one destined by fate to live at a pivotal moment in history, at the clash of two worlds that would, from then on, be merged forever.

Opposite
A colonial representation of the Templo Mayor (Great Temple) of Tenochtitlan, with the temples dedicated to Tlaloc (in blue) and Huitzilopochtli (in red). In the foreground a Mexica figure holds a weapon and turns to speak to a Spanish soldier. Between the two, a vertical drum is played.

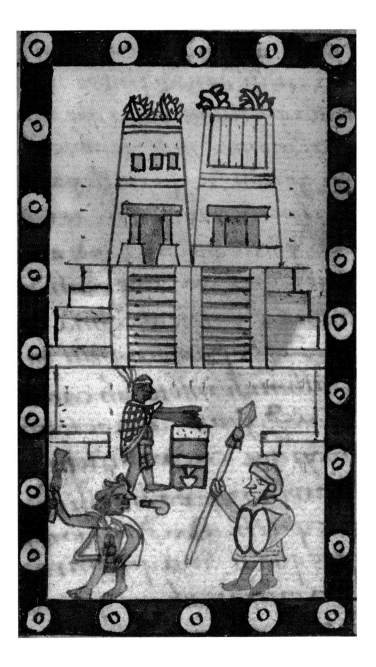

THE NEW RULER

AHUITZOTL had chosen within a restricted group of princes from his own family the man who would succeed him. When the time came, in 1502, the supreme military council of four, in consultation with the rulers of Tetzcoco and Tlacopan, deliberated and approved his decision. The new prince chosen to rule over their world had to be a religious leader to ensure the prosperity of his people, a skilled commander of the army and a strong political leader. Moctezuma II was the chosen one: son, grandson and nephew of previous rulers.

Moctezuma's accession to power started when he was divested of all his former insignias and clothing. Wearing only a loincloth, he climbed to the top of the Templo Mayor (Great Temple) to make copal offerings to the gods. Then, dressed in a green cape decorated with skulls and crossbones, he descended towards the Tlacochcalco (House of the Eagles) on the north side of the Templo Mayor. There he fasted and did penitence during four consecutive days and nights, revisiting the top of the temple to perform self-sacrifices and to invoke Tezcatlipoca (the god of night and destiny).

After these four days a procession took place towards a royal palace, where the ruler of Tetzcoco anointed the new *tlatoani* with his emblems of rulership. The ceremony became an investiture, a coronation and an enthronement that vested him with power. Moctezuma sat on a throne covered with eagle and jaguar pelts placed on a magnificent litter, to be paraded past deities and the ruling elite up to the front of the Templo Mayor.

After performing rituals in front of Huitzilopochtli's temple and carrying out self-sacrificial blood-letting, Moctezuma was taken in his litter around the ceremonial precinct and its many temples to pay tribute

Moctezuma II holding a spear and wearing the royal cloak, feathered arm ornament and the royal turquoise diadem (*xiuhuitzolli*). This royal diadem also forms Moctezuma's name glyph, seen at top left. Codex Tovar, 1583–87.

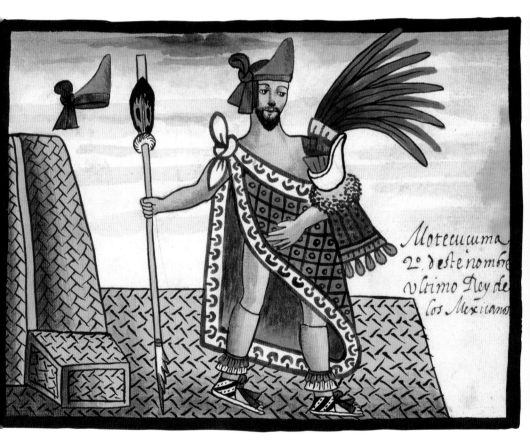

Motecuhuma
2º deste nombre
ultimo Rey de
los Mexicanos

to different deities. At the last temple of Yopico, dedicated to Xipe Totec, Moctezuma entered a cave where he performed self-sacrifices to the earth. The connection with the earth and the underworld symbolically transferred its power to the new *tlatoani*. Moctezuma emerged from the cave as a reborn semi-divine leader confirmed in his new role.

But he still had to prove his leadership and strength on the battlefield. Moctezuma commanded a military campaign to secure prisoners for sacrifice and tribute. Upon his triumphal return his army advanced to accompany his march into Tenochtitlan, and hundreds of prisoners were paraded through the city to show his power and skills in leadership and martial arts.

Invitations were sent to allied rulers and enemy nations to witness the confirmation of Moctezuma as the *huey tlatoani*. The whole Basin of Mexico bustled in preparation for the event. Craftsmen, artists and artisans were put to work, and new works commissioned for the embellishment of the capital city. Gifts were sent from all quarters of the empire to honour the new ruler.

Then the ceremony that confirmed Moctezuma as the great *tlatoani* began, lasting for four consecutive days. Parades, songs, dances, music and speeches, feasting and theatrical displays of power took place in the great sacred precinct of Tenochtitlan. The newly proclaimed ruler was paraded in his magnificent litter. From his throne he distributed insignias of rank to all the noblemen, displaying his superiority and reinforcing the new social order. Captives of the coronation wars were sacrificed, and Moctezuma asserted his power over the known universe.

This carved stone is thought to commemorate Moctezuma's coronation. The four past eras or Suns are carved at the four corners; and the present era, with the glyph *ollin*, is placed at the centre of the composition. The dates 1 Crocodile and 11 Reed correspond to 15 July 1503, possibly the date for Moctezuma's final coronation.

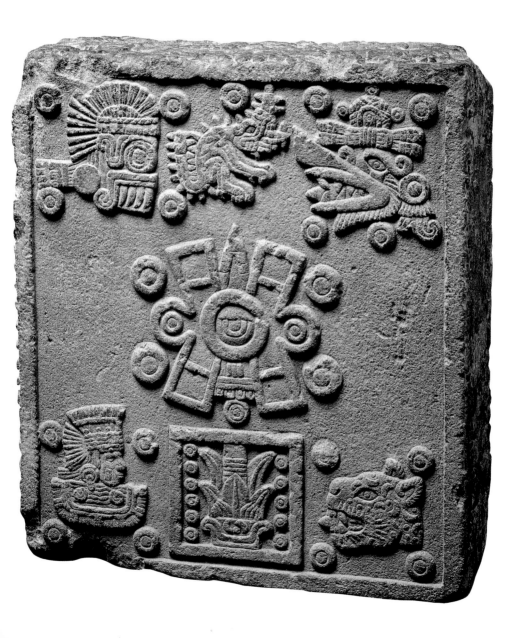

22

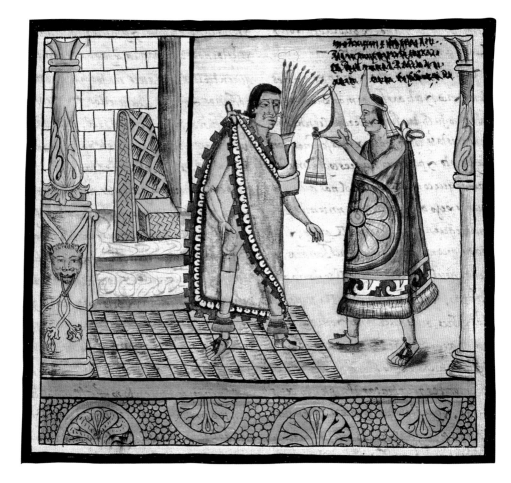

INSIGNIAS OF ROYAL POWER

Early colonial chronicles, like Diego Durán's, describe several insignias granted to the new ruler. Perhaps the most important one was his royal diadem, the *xiuhuitzolli*, a triangular gold diadem covered with blue turquoise mosaics that resembled the tail of a *xiuhcoatl*, or turquoise and fire serpent, a bearer of the years and light. Ear-spools made of gold and turquoise were given to Moctezuma and a stone nose piece was inserted in his septum. He was dressed in a fine woven blue cloak, and many pieces of jewellery, including a gold bracelet with feather decorations, were part of his new regalia. The *icpalli*, a woven reed throne, was the supreme seat of power and authority for the *tlatoani*. A reed mat had been the throne of earlier rulers but since the independence of Tenochtitlan from Azcapotzalco in 1430 this new symbol of authority was incorporated into the Mexica court.

Moctezuma is presented with his royal diadem (*xiuhuitzolli*). His woven reed throne is seen behind. *Historia de las Indias de Nueva España e isles de tierra firme*, Codex Durán.

THE PALACE AND COURT

AS a public statement of his power Moctezuma commissioned a magnificent new palace. The chosen location was just south of the sacred precinct, adjacent to the temple of Huitzilopochtli. This new palace would become the place from where Moctezuma would rule his empire.

The best craftsmen and artisans were taken into the city to work on this monumental project. The new structure, built on two floors, comprised numerous buildings, patios and courtyards. Recreational areas included lush gardens with wonderful flowers and clean pools, a house with colourful exotic birds and a separate area that housed examples of all the animals found throughout the empire, ranging from aggressive jaguars to poisonous snakes who slept in feather beds inside large woven baskets. The palace, known as the 'New Houses of Moctezuma', extended over five acres. It was the new home for the royal family and its accompanying court, housing hundreds of noblemen, guards, courtiers and servants.

As the nerve centre of the empire, administrative, political and economic decisions were taken in its council rooms. Moctezuma held regular state assemblies, received and housed allied rulers and dignitaries, and consulted on affairs of state with his council of four and with his closest advisors. Court cases were taken into the palace, where justice was dispensed, tributes and taxes were collected and records were carefully kept. Luxury goods were stored in the *calpixacalli*, to be redistributed as sumptuous gifts and as part of ostentatious state ceremonies. The granaries, known as *petlatalco*, were kept full to provide in times of famine and natural disaster. Even the high status prisoners of war were kept under surveillance close to the royal residence.

The Codex Mendoza illustrates an idealized portion of Moctezuma's palace. Moctezuma is sitting within a secluded upper chamber. In a lower room, to the right-hand side of the stairs, four advisors seated on a woven mat are conferring. Codex Mendoza, fol. 69r, *c*.1541.

69

trono y estrado de moteccuma
donde se sentaua/ a cortes y a juezes

moteccuma

casa donde aposentauan alos . se
napoa y chichimecatl y colhuacan
y eran sus huespe
des y confe
rado es de
moteccuma

casa donde aposentaua
con alos grandes señores de tezcuco
y tacuba y eran
sus amigos de
moteccuma

moteccuma

patio . delas casas
reales de moteccuma

y patio delas casas
reales de moteccuma

sala del conçejo de guerra

estas rayas
son subien
do/son andar
al patio delas
casas de mote
cuma que son
estas figuras

estos quatro son como oydores
del conçejo de moteccuma son
hombres sabios

sala del conçejo de moteccuma

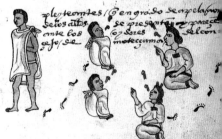

pleyteantes/y en grado de apelaçion
destos altos se presentauan y comparesçian
ante los al con
oydores del conçejo de çejo
moteccuma

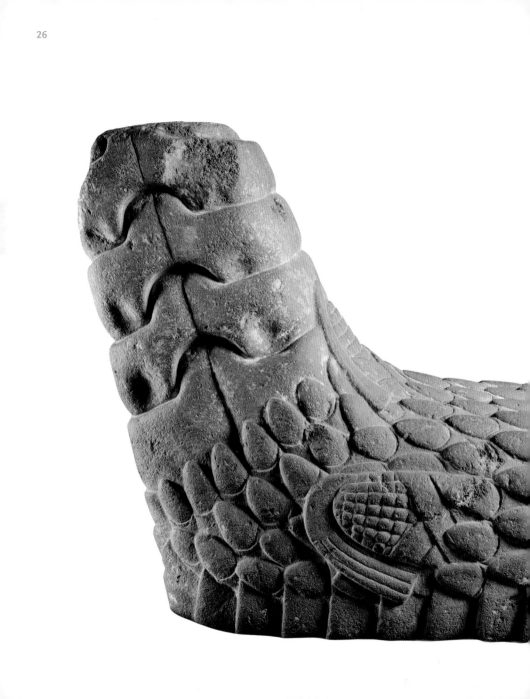

ARCHITECTURAL REMAINS

Monumental sculptures and painted polychrome friezes once decorated the palace grounds and its buildings. Little evidence remains of those magnificent works, but excavations under the current National Palace have revealed majestic and colourful architectural fragments, showing the elaborate and skilful carvings that once decorated those buildings.

This fragment of a once much larger sculpture might have flanked an entrance or a staircase. Mature corn cobs emerge between the scales of the serpent, which is notable for the rattle in the end of its tail.

Such sculpture might once have guarded the granaries of Moctezuma's palace, where corn was stored for redistribution in times of famine. The sculpture might have personified Cihuacoatl, the 'serpent woman', who was the provider of life and sustenance, and who perhaps acted as the guardian of the precious stocks.

Fragment of a rattlesnake
tail with corn cobs.

THE NEW COURT

Moctezuma not only built a new palace but he also replaced the members of his administration and court within it. Instead of the men appointed by the previous ruler Ahuitzotl, he brought in nobles or members of the royal family that he trusted. Servants in Moctezuma's court had to be of noble origin, and sons of lords from the tributary provinces were taken into the palace to serve the supreme *tlatoani* and to be educated in Mexica ways.

By such actions Moctezuma excluded any personal contact with commoners, enhancing his aura of power and his semi-divine status. He also aimed to strengthen his relationship with the nobility and keep closer control over the ruling elite.

Moctezuma lavished his noblemen with abundant gifts, signs of rank and privileges in order to sustain diplomatic alliances. Materials like gold and silver were exclusively the preserve of gods, royalty and noblemen, making a visual statement of the social hierarchy. The most lavish works of art, exotic goods and refined imported materials were enjoyed on a daily basis within the palace walls. Class differentiation became more evident during Moctezuma's reign, making social mobility and identity harder than ever.

This nose piece is a rare surviving example of Mexica goldwork. It is in the stylized shape of a butterfly. The combination of costume and ornament was carefully orchestrated to mark status and identity.

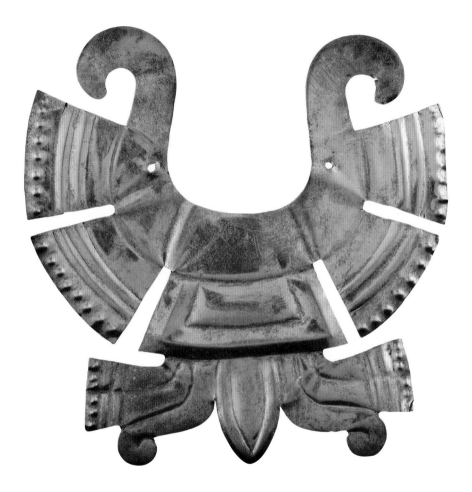

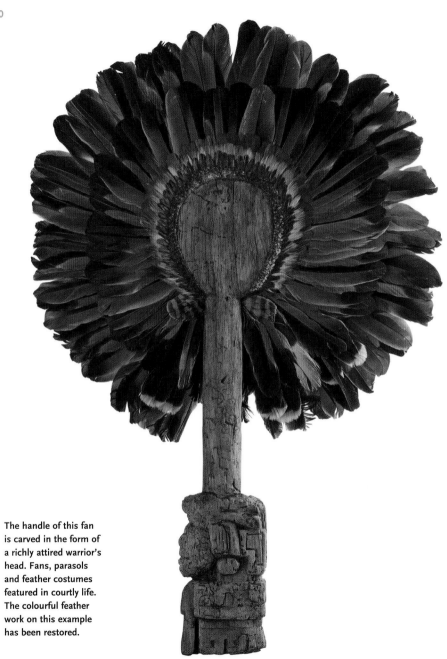

The handle of this fan is carved in the form of a richly attired warrior's head. Fans, parasols and feather costumes featured in courtly life. The colourful feather work on this example has been restored.

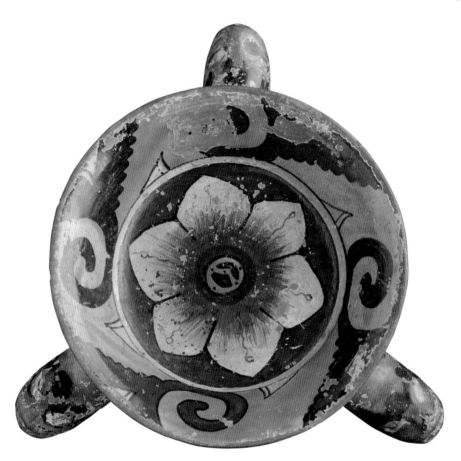

Moctezuma was said to use Cholula style polychrome pottery like that shown here in his daily meals and in court banquets. Tripod plates were a common shape in Mexica tableware.

TRIBUTE AND FEASTS

One of Moctezuma's main concerns during his reign was to secure the incoming flow of luxury goods from tributary provinces. Moctezuma consolidated and expanded his territories into the areas where he could find precious materials for consumption by his ruling elite.

Royalty, high-ranking noblemen and deities made lavish use of feathers, taken from colourful tropical birds, in elaborate adornments. These were conspicuously displayed in processions and major events as public statements of status and power. Precious materials, like turquoise and greenstones, were imported to be fashioned by the court specialists who produced the most exquisite masterpieces. Skilled artisans from all corners of the empire, who excelled in their techniques and designs, worked in the palace together with the best Mexica specialists.

Products were also imported to the capital to satisfy the personal desires of the *tlatoani*. Fresh fish was brought daily from the coast to be served at Moctezuma's table, among a vast choice of regional specialities. He took his meals behind a screen and large amounts were served, but he ate in moderation, picking and choosing from several delicacies. The leftovers were ritually discarded and the tableware, made of colourful Cholula pottery, was broken. At the end of his meals Moctezuma drank a small jar of foaming chocolate, one of the most precious goods imported from afar. Sumptuous feasts were also conducted in the court, where the most exquisite exotic foods were served in abundance. Singers, dancers and buffoons provided the entertainment for the court and its high-ranking guests.

This striking mask exudes power and intensity. The Mexica prized turquoise above all other materials for its intense bluish-green colour. They obtained it by long-distance trade and tribute taxation. Mixtec artisans excelled at cutting, polishing and setting the tiny pieces on to items such as helmets, ear-spools, and masks.

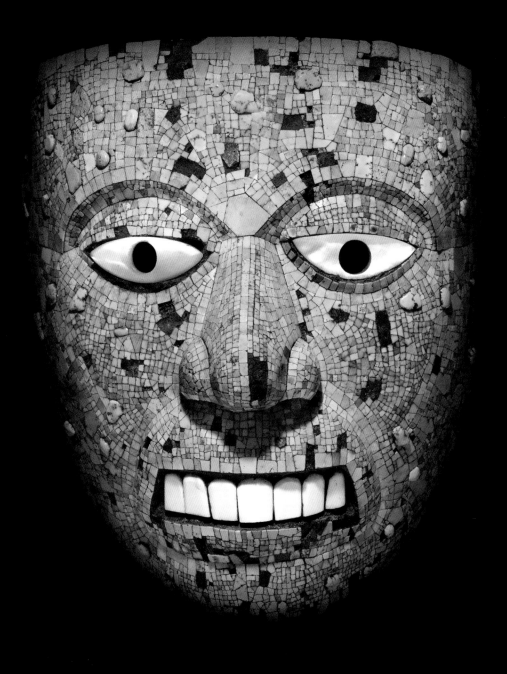

WARFARE

AS supreme ruler Moctezuma commanded the Mexica army. After he had proved his bravery and secured victims for sacrifice in his coronation war, Moctezuma aimed to consolidate the territories conquered by his predecessors and expand his domains.

Children were schooled and trained in martial arts, and bravery in the battlefield was one of the few means to scale the social ladder. Death in combat was regarded as an honour that ensured a position next to the sun for posterity. Mexica rulers justified their actions as following a divine mandate to ensure prisoners to sacrifice to their gods.

However, the constant requirement for goods and riches obtained by tribute and tax payments was the real motive behind these expansive campaigns. The lavish spending of Moctezuma's court, with its constant pomp, ritual and religious ceremony, the bountiful gifts to the ruling elites and foreign rulers, drove the need for further conquests and higher taxation in the provinces. Moctezuma sought to extend his empire towards the southern territories from where he could extract precious materials, including turquoise, cacao and feathers.

Despite the continuous efforts of Moctezuma's well-trained army, several areas remained undefeated. His multiple campaigns failed to conquer the fearless Tlaxcala, even though their land was surrounded by Mexica territory and they had no access to the coast. Securing strategic trade routes for professional merchants, *pochteca*, was also one of the priorities for the empire. Merchants maintained close ties with rulers and acted as diplomatic envoys and spies as well as ensuring the flow of exotic goods to the Mexica capital.

The Codex Mendoza shows a listing of the towns conquered by Moctezuma. Each town is indicated by a 'burning temple' next to the different toponyms or place names. Moctezuma, identified by his name glyph, sits in front of a shield with arrows, the emblem of war and conquest.

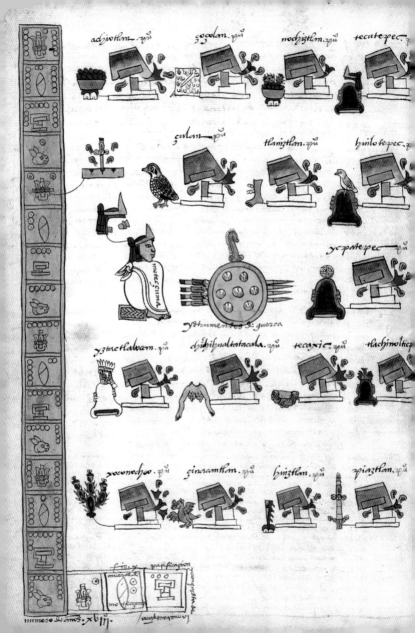

achiotlan. *zpu* çoçolan. *zpu* nochiztlan. *zpu* tecutepec.

çulan. *zpu* tlaniztlan. *zpu* huilotepec.

ycpatepec. *zpu*

yteumentos de guerra

yztactlalocan. *zpu* chichihualtotocala. *zpu* tecaxic *zpu* tlachinolti

xocomochco. *zpu* çinacantlan. *zpu* huiztlan. *zpu* xpiaztlan. *zpu*

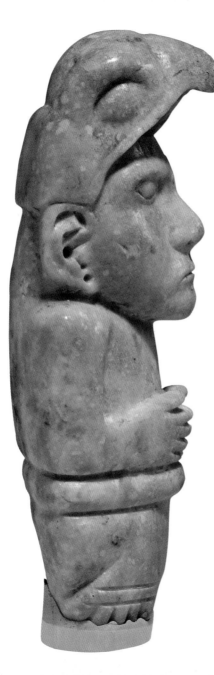

EAGLE AND JAGUAR

The highest military order, known as the *cuauhtli-ocelotl*, was composed of the eagle and jaguar warriors. They dressed in feather costumes and helmets that represented the two fiercest predators in the sky and on the land. Formed of the most skilled and brave soldiers and commanders, they had proved their worth on the battlefield by taking at least four captives for sacrifice. However, Moctezuma restricted the granting of these distinctions to members of the nobility. These warriors not only led in the battlefield, but their duties were related to the cult of the sun and the gods Huitzilopochtli and Tezcatlipoca, and they enjoyed a privileged relationship with the *tlatoani*.

Left
**Greenstone Eagle
Warrior figurine.**

Opposite
**Basalt seated Jaguar
Warrior.**

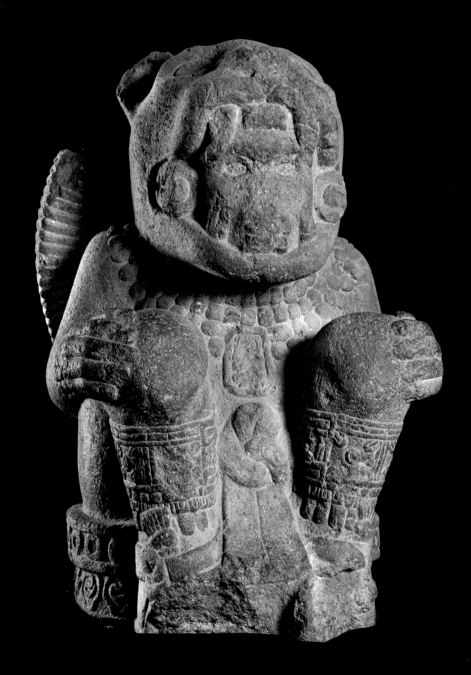

A procession of fourteen warriors, carved around
the four sides of this square block, marches
towards a ritual ball of grass, *zacatapayolli*, to
perform self-sacrifices. Each one of them wears

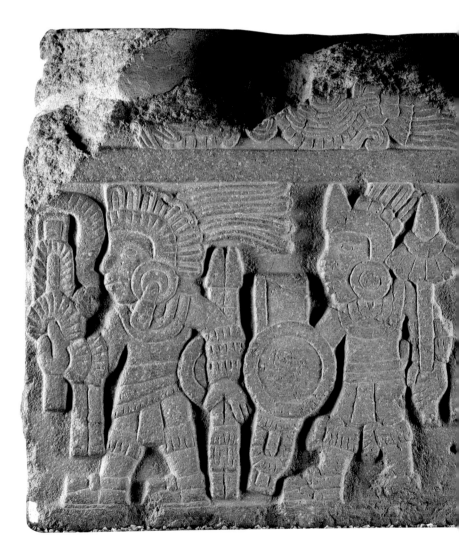

a different costume and regalia, which includes
headdresses, feather decorations, weapons and
elaborate ornaments. Such special costumes were
used to mark origin, rank and military achievements.

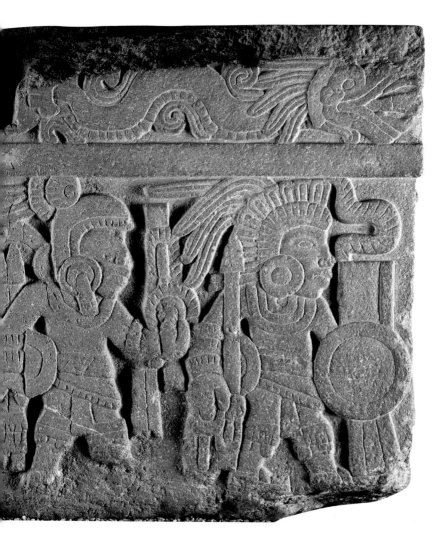

DRUMS

Marches to the battlefield, military parades and ritual ceremonies were accompanied by the rhythm of music. Drums, which were regarded as sacred objects, played a special role in those ceremonies, as they marked the pace of the battle and the orders given by the leaders. Two main types of wooden drum existed, the horizontal drum or *teponaztli*, and the vertical drum *huehuetl*. They were often decorated with meaningful iconography.

Right
A vertical drum (*huehuetl*) carved with a figure dressed as a majestic eagle. It was found at Malinalco, a provincial ceremonial and military centre closely related to the jaguar and eagle military orders.

Below
A slit drum (*teponaztli*) fashioned in the shape of a Tlaxcalan captive warrior. The musician would be striking the back of the warrior when playing the instrument, making a visual statement of the destiny of Mexica enemies.

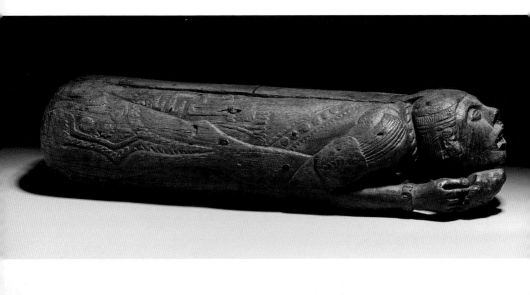

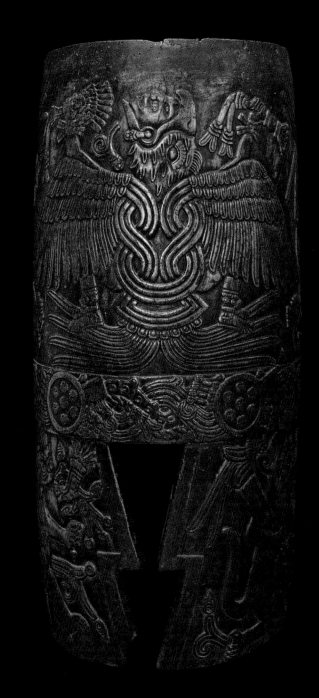

Fine.

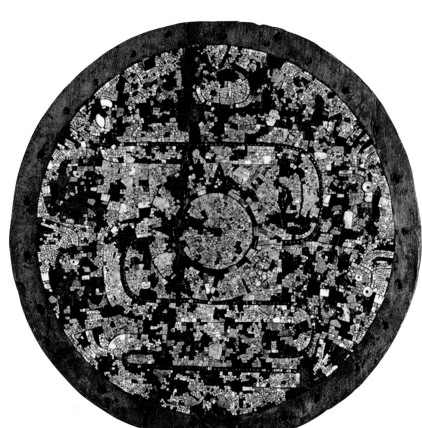

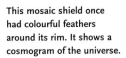

This mosaic shield once had colourful feathers around its rim. It shows a cosmogram of the universe.

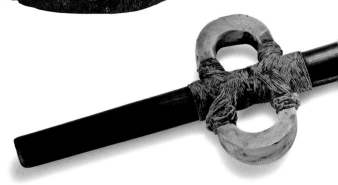

WEAPONRY

Weapons ranged from slings, stone knives, and bows and arrows
to lances, *macahuitls* (a bladed obsidian sword) and *atlatls* (spear
throwers). Defensive garments included protective shields, helmets
and padded cotton armour. Elaborate weapons were fashioned
for the ruling elite, sometimes to be used in ritual ceremonies rather
than on the battlefield. Among those turquoise mosaic shields and
carved *atlatls* are examples displaying intricate iconography.
In some instances they symbolically placed the warrior at the centre
of the world and under divine mandate and protection.

This spear-thrower
(*atlatl*) has carved on
one side a menacing
snake intertwined with
a fully armed warrior.
He represents Mixcoatl,
the Mexica god of
war, wearing a heron-
feathered headdress
and menacing fangs.
Together they symbolize
the power of the
flying dart.

GODS AND SACRIFICE

AS a semi-divine ruler Moctezuma orchestrated most of the important religious public ceremonies and took part in major ritual events. These were set up to ensure the stability of the cosmos and the well-being of his people. The Mexica feared imminent natural disasters that could end the present era or 'Fifth Sun', so divine intervention was necessary to avoid the end of the world.

According to Mexica legend, each night the earth, in the form of the earth goddess Tlaltecuhtli, swallowed the sun. Its journey through the underworld culminated in a moment of uncertainty awaiting the dawn. Rituals to the earth had to be performed to ensure that the sun would rise again every morning. It was not only the sun that was vital to sustain life on earth; life-giving water, in the form of rain, and springs and rivers flowing from the earth, was a key source of abundance. Some of the major Mexica gods were closely linked with agriculture, fertility, abundance and renewal. On the other hand, the warrior-like divinities were engaged in cosmic battles, stirring up the need for warfare as part of a divine mandate. These battles were needed to maintain cosmic order and to supply captives for sacrifice.

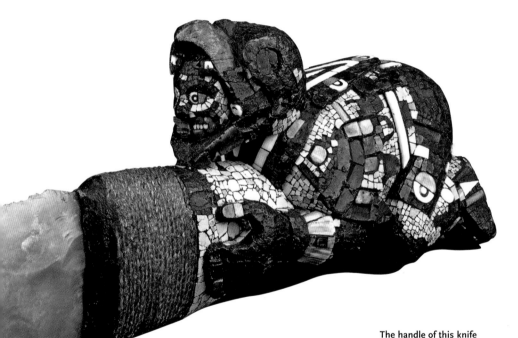

The handle of this knife is fashioned in the form of a crouching Eagle Warrior. His face peers out from the open beak of the headdress and he clasps the blade in outstretched hands. His body is covered in intricate mosaics of different materials.

Offerings to the gods usually included food, aromatic resins like copal, animal sacrifices and ritual objects. However, the most precious offering was one's life. The Mexica had found ways to please their gods without giving up their lives. Prisoners of war and slaves were used as surrogates. Once a prisoner was taken captive on the battlefield he became one with his captor. Offering the life of one's prisoner was like giving one's own blood. Rulers, priests and members of the ruling elite also let blood from several parts of their bodies to perform self-sacrifices. The blood was collected in balls of grass, and every drop was precious.

Moctezuma conducted strict and regular self-sacrifice, letting blood by piercing his body with cactus spines and bone implements. His precious blood ensured the stability of the cosmos. Moctezuma made majestic appearances dressed as a god at major religious ceremonies and public events, becoming one with the divinities and reasserting his semi-divine status.

Astronomers and priests advised the ruler in religious affairs. As supreme *tlatoani* he was the mediator between his people and the gods. To communicate with the divine he owned several religious implements. Among these was a double-faced mirror made of dark polished obsidian that he used to see his people and all that took place in the world. The ruler also made use of his mirror to communicate and interpret the wishes of deities who would guide him on the right path.

A figure with crossed legs, probably the ruler himself, is seated against a background of human hearts. He is piercing his chest to perform an act of self-sacrifice. The date 10 Rabbit, carved above his head, corresponds to 1502.

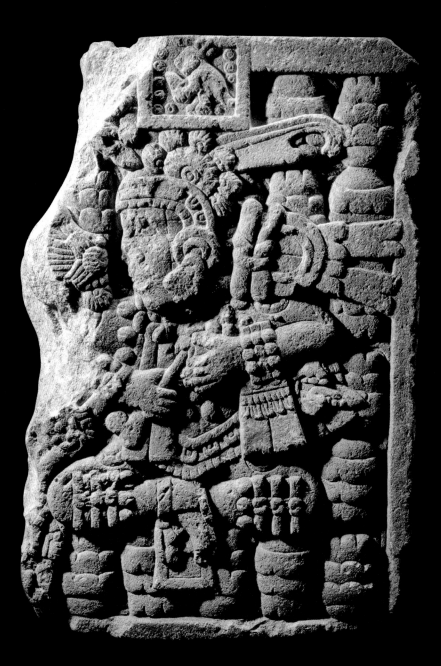

THE SACRED PRECINCT AND THE TEMPLO MAYOR

The main sacred precinct at the heart of Tenochtitlan housed
numerous buildings and temples dedicated to the major deities
of the Mexica pantheon. Enclosed within a walled area, its access
would have been restricted to selected individuals and priests
who were constantly in attendance worshipping the divinities. Major
structures, like the ball court, the temple for captive idols from
conquered towns, and *tzompamtis*, the skull racks on which the
heads of sacrificial victims were publicly displayed, were among the
many buildings in the precinct.

The largest monumental structure was an imposing 45-metre-
high pyramid, known as Huey Teocalli or Templo Mayor (Great
Temple), with two staircases flanked by sculpted serpents. Each
Mexica ruler in turn enlarged and embellished the building,
commissioning a new phase of construction and increasing its size.
This pyramidal platform was the main stage for ritual ceremonies
and a visual reference to the mythical Coatepetl (Snake Mountain).
At the top, two temples were placed side by side: on the left, the
one dedicated to Tlaloc, the rain god, and on the right, the temple
of Huitzilopochtli, the patron god of the Mexica.

Mexica rulers rewrote their history to justify their supremacy,
and they incorporated old gods into their pantheon to legitimize
their ruling presence in the Basin of Mexico. Tlaloc was the old god
that exemplified the sedentary and agricultural roots of the native
inhabitants of the Basin of Mexico. Huitzilopochtli, on the other
hand, was a nomadic god, who led the Mexica on their long
migration to find the promised land. He was a hunter and a warrior
and his actions justified wars and sacrifices. Moctezuma was
directly involved in the cult of those figures that dominated the
city from their privileged position. He regularly climbed to the top
of the Templo Mayor, as he did during his coronation ceremony,
to perform rituals and celebrate the gods.

A schematic depiction of
the sacred precinct of
Tenochtitlan. Among
other buildings is the
Templo Mayor, with the
twin temples of Tlaloc and
Huitzilopochtli. *Primeros
Memoriales*, fol. 269r.

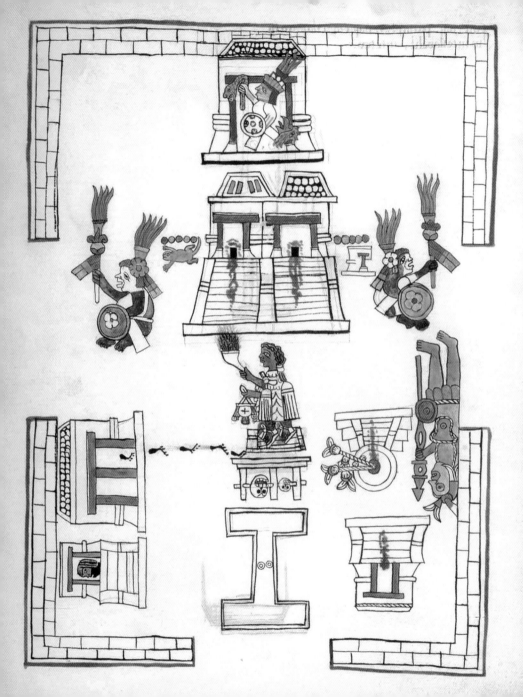

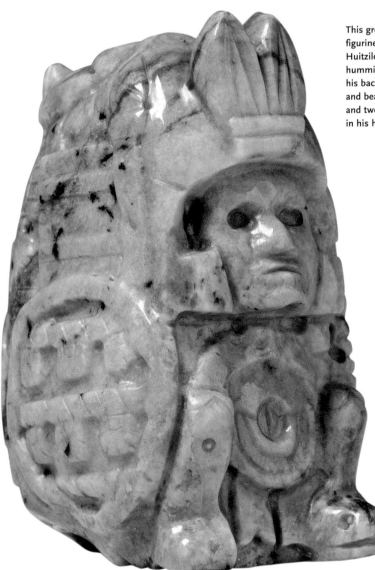

This greenstone figurine is identified as Huitzilopochtli by the hummingbird carved on his back. He is armed and bears a round shield and two heron feathers in his headdress.

HUITZILOPOCHTLI

Huitzilopochtli was the tribal god of the Mexica. He led them in their long migration from Aztlan, their mythical place of origin, to the place where they would found their new capital of Tenochtitlan. As a tribal god he exemplified the hunter-gatherer attributes of the Mexica during their nomadic wanderings. He was a god associated with war and sacrifice, and is usually portrayed as a fully armed warrior including a shield decorated with rows of eagle down.

His main identifying symbol was a hummingbird worn as a headdress or attached to his back. Huitzilopochtli means in Nahuatl 'left-sided hummingbird' or 'hummingbird of the south' and corresponds to the sun's position as it rises from the eastern horizon to its zenith, reinforcing the deity's solar associations. In the northern hemisphere, during most of the year, the sun inclines towards the south, hence the name 'hummingbird of the south'. Moreover, following the path of the sun in the sky, the south is located on its left side, hence the name 'left-sided hummingbird'.

The birth of Huitzilopochtli is in itself a history of war and triumph. The story takes place on the mythical mountain of Coatepetl (Snake Mountain). The goddess Coatlicue had become pregnant by a down ball while sweeping the temple stairs. From this magical conception Huitzilopochtli would be born. However, his sister Coyolxauhqui became extremely angry and called her 400 brothers (the stars) to kill their mother and her unborn child. As they approached the top of the mountain Huitzilopochtli was miraculously born as a fully armed warrior and defeated his rebellious sister. Coyolxauhqui was decapitated and her body was thrown down the mountains, being dismembered in its fall.

Huitzilopochtli's myth was reenacted in the Templo Mayor, at the heart of Tenochtitlan, where monumental sculptures reminded people of the power of the Mexica's patron god and the destiny of his enemies.

TLALOC

The rain god Tlaloc was one of the older gods in the Basin of Mexico. For the Mexica, who had incorporated him into their pantheon, he exemplified the powerful weather phenomena, including rain and lightning, whose actions were necessary to fertilize the land and ensure agricultural production. Settled agricultural traditions contrasted with the nomadic origins of the Mexica, embodied by their patron god Huitzilopochtli. Tlaloc and Huitzilopochtli stood side by side on top of the Templo Mayor, exemplifying the power of the old and the new, and the forces that drove the Mexica empire.

The left side of the Templo Mayor, where Tlaloc stood, was aligned with Mount Tlaloc on the eastern horizon. Tlaloc was thought to have originally lived in mountain caves. Rituals took place on the temple constructed on top of Mount Tlaloc, and Moctezuma himself might have climbed the mountain to ensure the arrival of annual fertilizing rains that came from the south-east.

Tlaloc was characterized by large goggle eyes, which are formed by two serpents that intertwine at the nose. In some instances the rattles of the serpents' tails form the eyebrows of the figure, and the fangs of the serpent become part of the fanged mouth of Tlaloc. His effigies were usually painted blue or constructed in blue and greenish turquoise mosaics recalling the life-giving water and the green foliage of agricultural vegetation.

This striking turquoise mask is formed of two serpents, one green and one blue. Each encircles one of Tlaloc's eyes and intertwines across the nose, with their rattles placed as eyebrows. The turquoise recalls luxuriant green foliage and life-giving water.

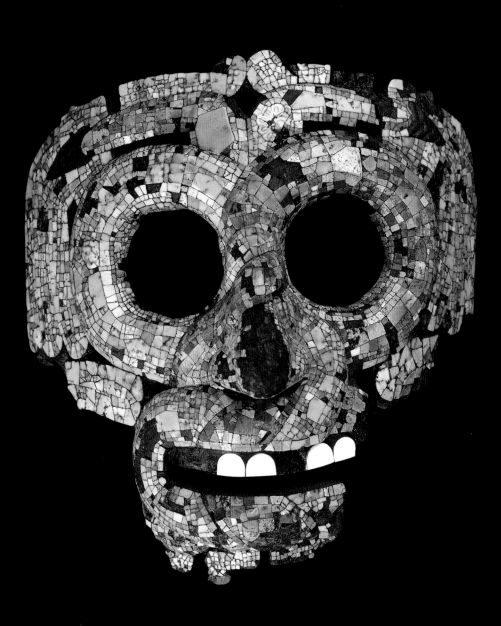

Detail at the back of
Tlaloc's sculpture showing
Moctezuma's name glyph.

Opposite
**Sculpture of Tlaloc,
the rain god, with his
characteristic goggle
eyes and fanged mouth.**

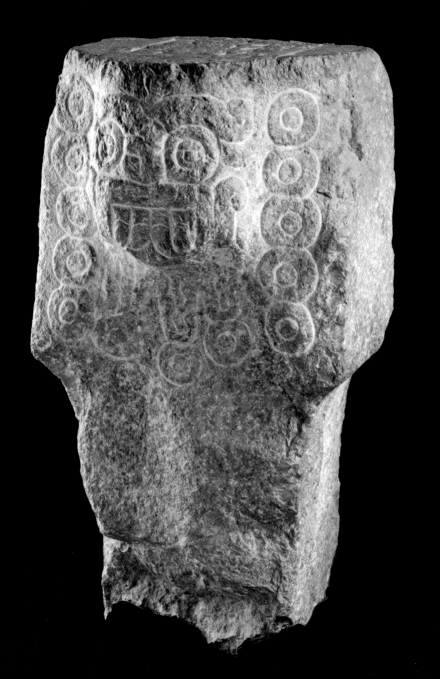

TEZCATLIPOCA

Tezcatlipoca was the omnipotent deity of the Mexica pantheon, a god of war, destiny, sorcery, divination and night. Tezcatlipoca means 'smoking stone or mirror' and he is frequently pictured with a round mirror and smoke scrolls on his left foot, headdress or at his temples, accompanied sometimes by balls of eagle down symbolizing sacrifice.

He was the patron god of Mexica royalty, and smoking mirrors may have been a metaphor for rulership and power. Mexica rulers claimed that they could use double-sided mirrors, made of highly polished black obsidian, to predict the future, as they possessed some of Tezcatlipoca's divinatory powers.

Tezcatlipoca's face is sometimes shown with horizontal bands of yellow and black, representing warrior facial painting. He shared many attributes with Huitzilopochtli, the other warrior deity closely associated with royalty. Huitzilopochtli is sometimes given the name 'the blue Tezcatlipoca' (of the south), sharing iconographic features. In some representations the two figures may merge into one.

This human skull was cut at the back and covered with mosaics. Bands of blue turquoise and black lignite might identify the blue Tezcatlipoca, a deity that merges with Huitzilopochtli. Two red deerskin straps were used to tie the skull around the waist of a deity impersonator, warrior or priest.

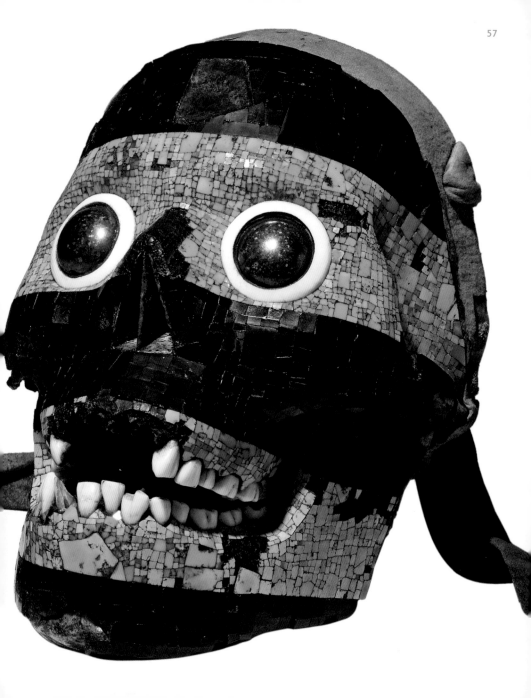

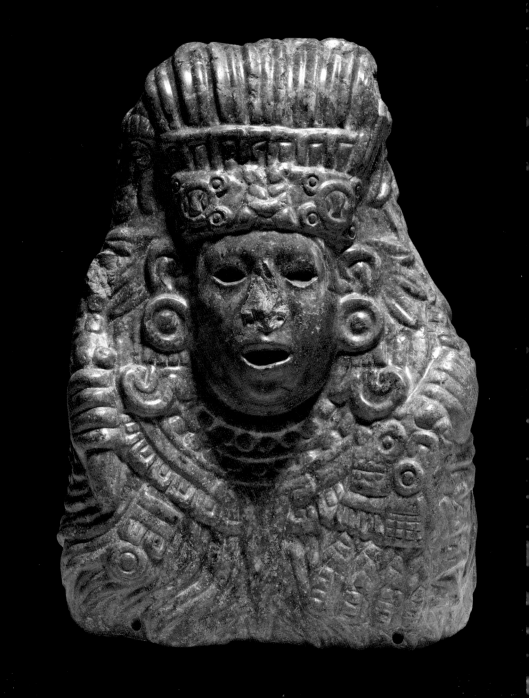

QUETZALCOATL

Ehecatl-Quetzalcoatl was the patron deity of rulers, the god of wind and the creator of humankind, among other roles. Quetzalcoatl means 'plumed serpent' and he is sometimes represented as a coiled or undulating feathered snake with menacing fangs. His green plumage recalls the lush greenery brought about by the rains, which he announces as carrier of the wind.

During Postclassic times, the mythical 'plumed serpent' took on human form and attributes. In Mexica stone carvings he is commonly represented with a human face emerging from a serpent's jaw and with a feathered serpent's body. His identifying attributes include curved conch shell ear ornaments called *epcolloli* and a cut conch pectoral ornament known as *ehecacozcatl* or wind jewels.

Ehecatl-Quetzalcoatl was also considered the god of the morning star, leading the sun to the zenith of the sky, while his twin Xolotl is the evening star. Xolotl is usually portrayed in skeletal form accompanying the sun on its nightly journey.

This greenstone bust shows Quetzalcoatl in his aspect of Venus, the morning star. He raises the sun to its zenith every morning, represented here by the sun disc that he wears around his neck. The back of the figure shows an ascending feathered serpent.

XIUHTECUHTLI

Xiuhtecuhtli was a god associated with fire, heat and the sun, whose name can be translated as 'turquoise lord'. The 'turquoise lord' had a close relationship with the mythical *xiuhcoatl*, the turquoise fire serpent. *Xihuitl* means both turquoise and year, keeping close association with time.

Xiuhtecuhtli usually wore decorations made of turquoise plaques or mosaic. Among these, he wore a turquoise pectoral ornament in the form of a butterfly. Butterflies were associated with the sun and renewal; they represented the souls of warriors who died on the battlefield.

Xiuhtecuhtli was identified with young warriors and rulers. Moctezuma himself impersonated Xiuhtecuhtli in public ceremonies, becoming one with the deity. Both the god and the ruler wore the *xiuhuitzolli*, the triangular gold and turquoise diadem that identified rulers and was used by Moctezuma in his name glyph.

Statue of Xiuhtecuhtli wearing the triangular turquoise diadem, turquoise ear-spools and a nose ornament. The sculpture is clothed in a *xicolli*, a tunic decorated with four circles and tied at the front.

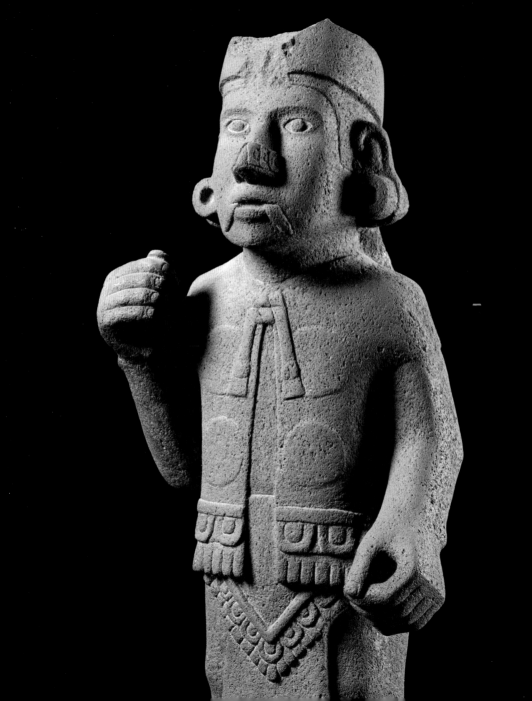

This casket was probably used to store Moctezuma's sacrificial instruments. Moctezuma's image is carved on one of its sides drawing blood from his earlobe as an offering to the gods.

PATRONAGE AND PUBLIC IMAGE

MOCTEZUMA chose to portray his image and to inscribe his presence on major monuments as part of his political and ideological strategy. His predecessors had themselves depicted in stone reliefs to legitimize their authority and their role as semi-divine and military leaders. Moctezuma II took this practice to a new level, carefully controlling his image and its position within Mexica cosmic and historical frameworks.

During Moctezuma's reign carving styles developed from the fairly flat reliefs to more fully three-dimensional sculptures. The new imperial style of art incorporated elaborate works combining complex iconography with mythical and historical dates.

Moctezuma chose to portray his image in two different ways. The first was as an anthropomorphic figure, usually attired as a divinity or major patron god. The second was by rendering his presence in his name glyph, standardizing it and making it easily recognizable.

A unique *tepectlacalli*, or stone casket, uses both forms of representation in portraying Moctezuma. Carved on eight of its faces, including the lid, it combines different dates with figurative imagery. On one side Moctezuma is portrayed seated in a cross-legged position. He is drawing blood from his earlobe with a bone perforator and carries an incense pouch. On his back he wears an elaborate jaguar's head ornament and his headdress combines two down balls with a pair of long feathers.

Moctezuma's name glyph is carved on his back. It is based on the *xiuhuitzolli*, a triangular gold diadem with blue turquoise mosaics, worn by rulers or deities. The royal diadem lies on top of short hair with an ear-spool and a nose ornament in front of it. This standardized glyph is complemented here with four plaited strips on top of the

hair symbolizing penitence and fasting, thus emphasizing the act of self-sacrifice that Moctezuma is performing. The triple speech scroll, with a feathered element at the top, is part of Moctezuma's glyph and identifies him as the *huey tlatoani* or 'great speaker'. However, in this carving it is not placed next to his glyph. Instead the scroll emerges from Moctezuma's mouth. The artist has fully integrated the figure with the glyph in this unique representation, making explicit the relationship between the two.

Moctezuma set his portraits within a broader iconographic discourse. In this casket the top of the lid shows a descending feathered serpent, Quetzalcoatl, flanked by two different year glyphs. Inside the lid is a skull carved in profile in enclosed bands, the outer one decorated with night eyes half closed, the whole symbolizing Venus. Inside the base of the box the glyph 1 Crocodile marks the creation of the calendar and the earth. On the underside the image of Tlaltecuhtli, the earth goddess, covers the whole surface.

The casket presents a cosmogram that reinforces the role of the ruler in communicating with supernatural forces. The lid symbolizes the sky while the base of the box represents the earth. Moctezuma is positioned between the two as the mediator, surrounded by mythical and historical dates, and performing sacrifices to ensure the stability of the cosmos.

Top
Lid showing a descending feathered serpent (Quetzalcoatl) flanked by two year glyphs, 1 Reed and 7 Reed, enclosed in cartouches. Both dates are associated with Quetzalcoatl, marking his mythical birth and death in the Mexica calendar.

Bottom
The earth goddess Tlaltecuhtli, with clawed hands and feet, carved on the underside of the casket.

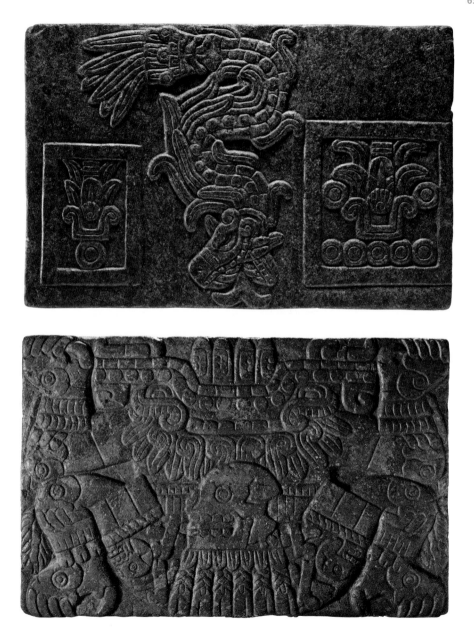

66

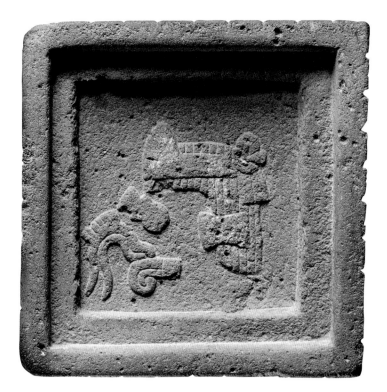

Opposite
Moctezuma's name glyph appears on several stone caskets, or *tepetlacalli*,
marking the commissioning or possession of these special objects by the *tlatoani*.

Above
Underside of a lid. Moctezuma's name glyph is composed of a triangular gold diadem,
which was decorated with blue turquoise mosaics and tied at the back of the head
with a knotted red leather thong. The diadem is placed on top of short hair, seen in
profile, and displaying an ear-spool. Below it a nose ornament and a triple speech
scroll identify the ruler as a great speaker.

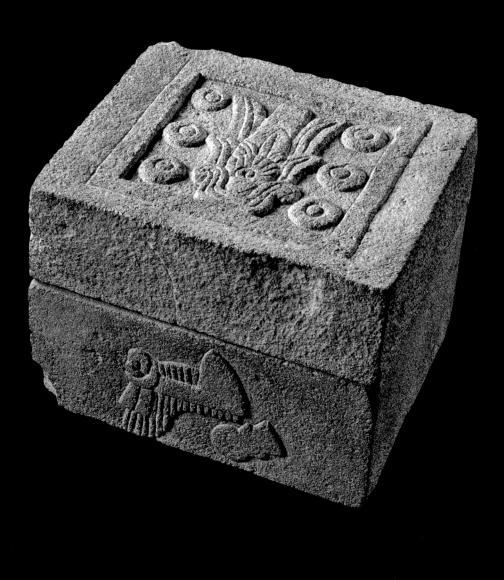

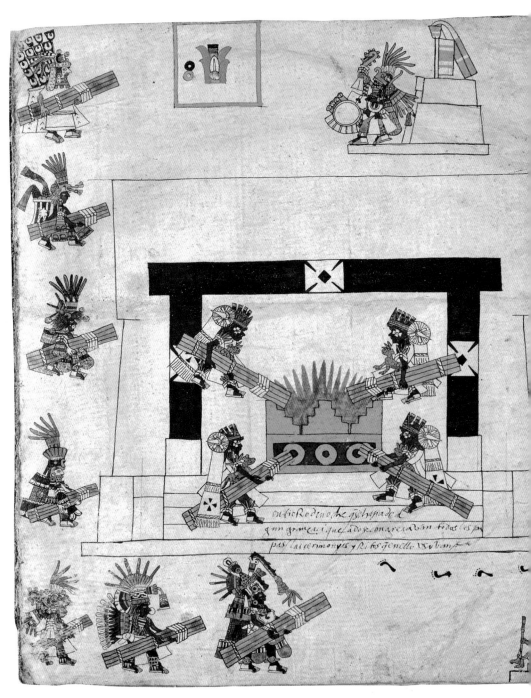

en esto Rodeno che q̃ se hazia de el
gran conçerq̃ se a do se conçer cabā todas les pi
pas las cerimonyes y Ribos q̃ enello lle vam

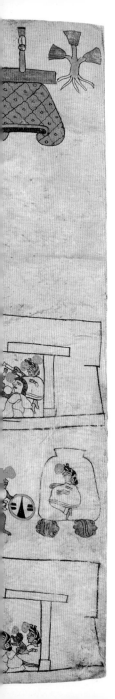

THE NEW FIRE CEREMONY

One of the major events that took place during Moctezuma's reign was the completion of a 52-year calendar cycle when the solar and lunar calendars met again on the same day. This momentous event fell in the year 2 Reed, corresponding to 1507. This was a time of uncertainty when darkness could fall over the world forever. To ensure the continuity of life and the sun's daily journey through the sky a special intervention was needed: this was the New Fire Ceremony. All fires in the empire were extinguished, and old possessions, like ceramics, were thrown away and smashed. People protected themselves with masks and pregnant women were kept indoors. When darkness had fallen a chosen victim was sacrificed at the Hill of the Stars or Huixachtepetl. From his open chest a new fire was started. The ignition of the new fire would secure life and light in the universe for another 52 years. Tied bundles of 52 reeds carried the fire to the Templo Mayor, and from there it was distributed to the four corners of the empire to light all the temples and house fires. Moctezuma presided over the ceremony, securing the future of his people.

The date 2 Reed marks the year 1507 and the celebration of the New Fire Ceremony. Moctezuma is depicted at the top centre dressed as the Mexica patron deity Huitzilopochtli. The fire has been ignited on the hill to his right, and footsteps mark the procession that took the new fire to the temple. Four fire priests light their reed bundles in the central hearth. Codex Borbonicus.

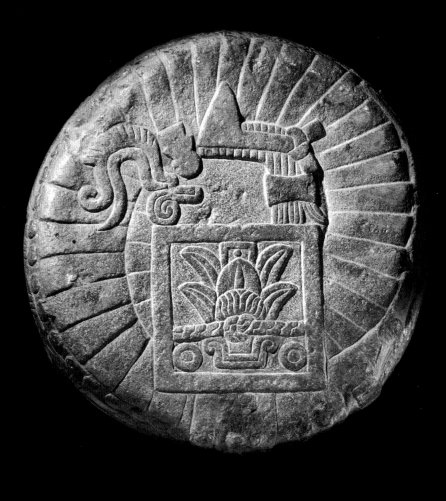

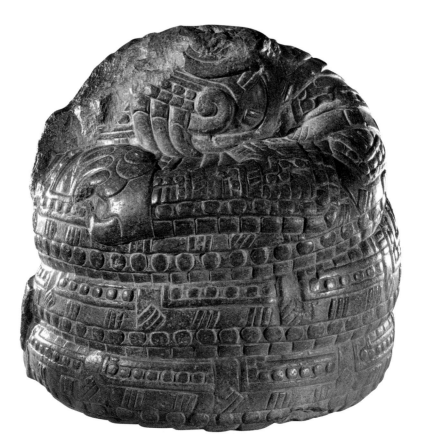

This coiled serpent represents a *xiuhcoatl* or fire serpent, a mythical creature whose name translates as 'turquoise snake'. On its underside (left) two glyphs mark Moctezuma's patronage of the New Fire Ceremony or *xiuhmolpilli* (binding of the years). By binding the date, 2 Reed, with a knotted cord, the artist made a direct visual reference to the rituals that took place on that date. Above it, Moctezuma's name glyph reinforces his presence and his patronage of the event. Elaborate carvings on the underside of Mexica works show that it is not only what can be seen that is important; what is there but not seen has equal relevance.

THE *TEOCALLI* OF SACRED WARFARE

Moctezuma commissioned several stone carvings to assert his key role in ensuring the continuity of the universe and the cycle of time. The best-known example is the so-called *Teocalli* of Sacred Warfare, a large monumental stone block in the shape of a temple. Flanking its central staircase the date 2 Reed, tied in a rope, marks the success of the New Fire Ceremony. Above this glyph stands Moctezuma, portrayed as a full standing figure dressed as Tezcatlipoca (the god of night and destiny). He flanks a sun disc together with Huitzilopochtli (the patron god of the Mexica), who wears a hummingbird headdress, and is placed above the date 1 Rabbit. They both hold in their hands a cactus spine for self-sacrifice as 'burning water', the symbol for warfare and conquest, emerges from their mouths to proclaim the need for war and sacrifices to maintain the cycle of life. At their feet, Tlaltecuhtli, the earth goddess, flanked by two shields and darts, receives the shed blood, thus allowing the sun to rise every morning. Moctezuma's name glyph is carved next to his figure, reinforcing his identity and his position on a par with the gods.

The *Teocalli* of Sacred Warfare is a monument that commemorates the New Fire Ceremony. It is shaped as a pyramid with steps leading to a temple. It celebrates the triumph of the sun in the universe and legitimizes the power of Moctezuma.

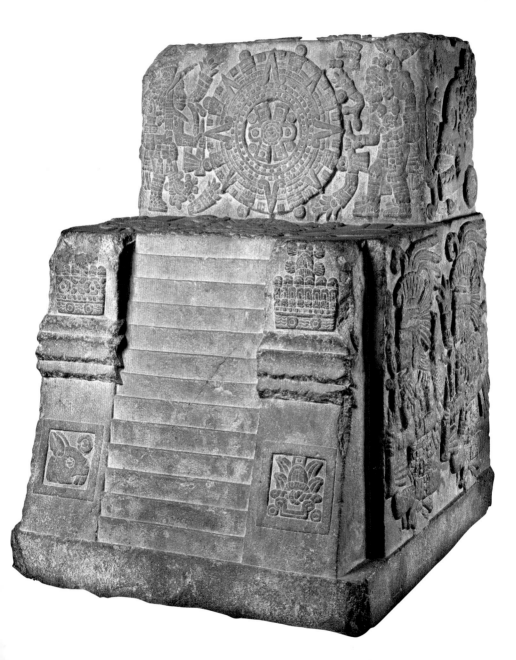

SUN STONE

This circular monolith, known as the Sun Stone, is one of the largest Mexica stone carvings that has survived, dating from Moctezuma's reign. At the centre is a clawed deity shown from the front, embedded in the *ollin* symbol, the x-shaped glyph that marks the present era that will end with earthquakes. The glyph names of the four previous eras, which had also ended in disastrous events, are encapsulated within the four sides of the *ollin* sign. Above it, Moctezuma's name glyph is facing the date 1 Flint. Circular bands surround the central composition, including the 13 day glyphs of the 260-day divinatory calendar. A sun disc with sacrificial connotations encircles the outer side. This monument is a reminder of Moctezuma's responsibility to maintain the cycles of time, and to ensure the sacrifices required for the daily return of the sun. Two descending fire serpents flank the full composition.

The Sun Stone, a monument commissioned by Moctezuma II. At its centre is the frontal face of a deity with clawed limbs embedded within the *ollin* symbol that represents the present era or Sun.

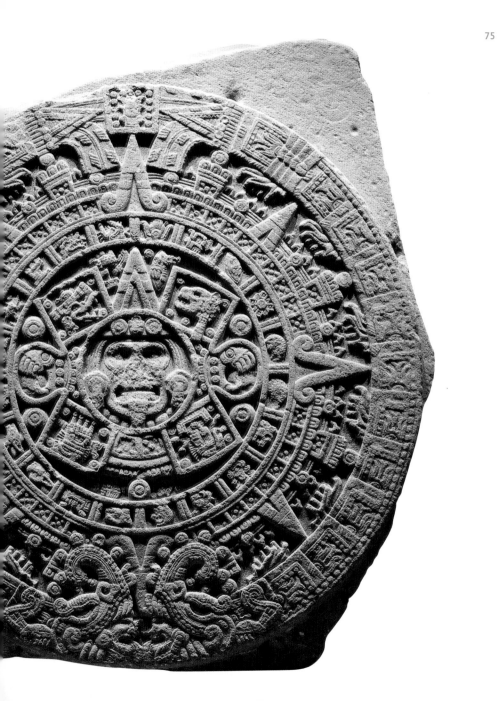

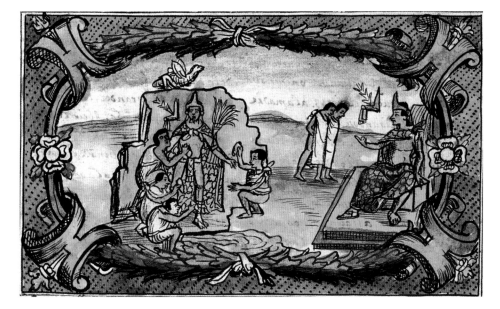

THE ROCK PORTRAIT AT CHAPULTEPEC

A tradition of sculpting the ruler's image in the rock at Chapultepec, or Hill of the Grasshopper, started during the reign of Moctezuma I (1440–69). Later *tlatoque* followed this tradition, commissioning their portraits when they felt their reigns were about to end. Moctezuma II's image was carved around 1519 to celebrate his 52nd birthday. He chose to portray himself as Xipe Totec, the warrior god of renewal who dressed in the flayed skin of a sacrificial victim. Fully armed and standing on a source of water, Moctezuma was flanked by six glyphs. These encapsulate his reign and reinforce his central role in the functioning of the cosmos. Among them, on Moctezuma's right, is his name glyph, with the symbol for war, 'burning water', commanding to battle. On his left, the glyphs are more defaced, but 1 Reed can still be seen. This is the date mythically related to Quetzalcoatl, which fell during Moctezuma's reign in 1519, the same year that Spanish ships landed on Mexica shores. Moctezuma aimed to make his image permanent at the time when his world was about to collapse.

Moctezuma I supervising the sculpting of his own image at Chapultepec Hill. Codex Durán, fol. 91v.

Opposite
Hypothetical reconstruction of the sculpted relief at Chapultepec Hill showing Moctezuma II dressed as Xipe Totec.

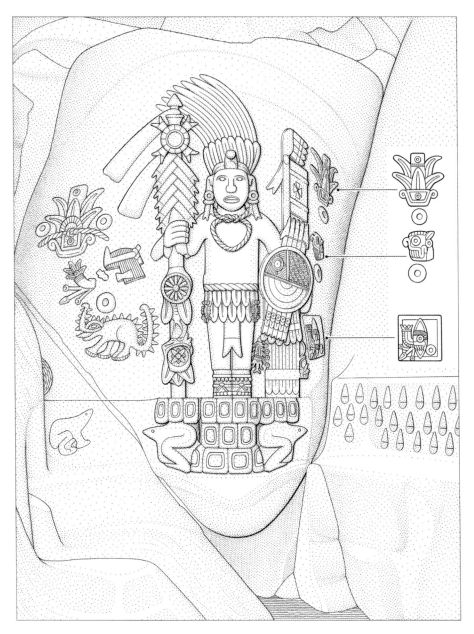

THE LAST DAYS OF MOCTEZUMA

BY April 1519, the year 1 Reed in the Mexica calendar, Cortés had set up camp near Cempoala, on the Gulf coast of Veracruz. News of the coming of strangers had already reached Tenochtitlan, with talk of bearded white men who had arrived from the east (the direction of authority). Moctezuma gathered his council to consult on the best course of action. The conflation of the calendar date 1 Reed with the mythical date related to the god Quetzalcoatl and the arrival from the sea of the strangers might have influenced how they decided to act.

Moctezuma sent gifts to the newcomers, including food, discs made of gold and silver, and four elaborate ritual costumes for god impersonators that displayed lavish feather work, turquoise mosaics, gold, shell ornaments and greenstones. Soon after the exchange of gifts, and fascinated by the prospective wealth of this empire, Cortés started his march towards Tenochtitlan. Spies kept the Mexica court informed of his advance. Cortés and his men crossed Tlaxcala lands, defeating the long unvanquished Mexica enemies and turning them into their powerful allies.

Having heard of the supremacy in weaponry and military tactics of the Spanish soldiers, Moctezuma tried to ambush them at Cholula, but all his efforts were in vain. Cortés and his men soon crossed the pass between the snow-capped volcanoes Popocatepetl and Iztacci-huatl as they marched towards Tenochtitlan. The first sight of the magnificent capital astounded the Europeans, as Bernal Díaz del Castillo writes:

'We arrived at a broad causeway ... and when we saw so many cities and villages built in the water and other great towns on dry land and the straight and level causeway ... we were amazed and said that

This page of Durán's chronicles depicts the great comet, the first of eight portents that supposedly announced the Spanish invasion and the fall of Tenochtitlan. Moctezuma is standing on the roof of his palace watching the comet in the night sky. Diego Durán, *Historia de las Indias de Nueva España y Yslas de Tierra Firme*, c.1579–81.

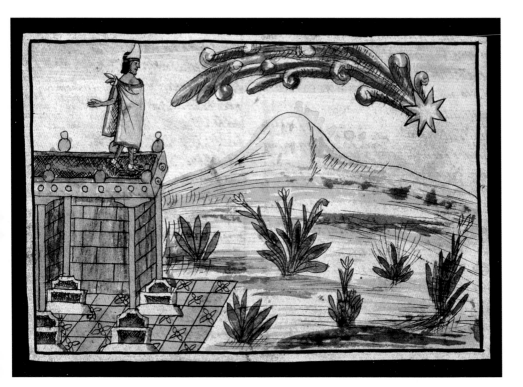

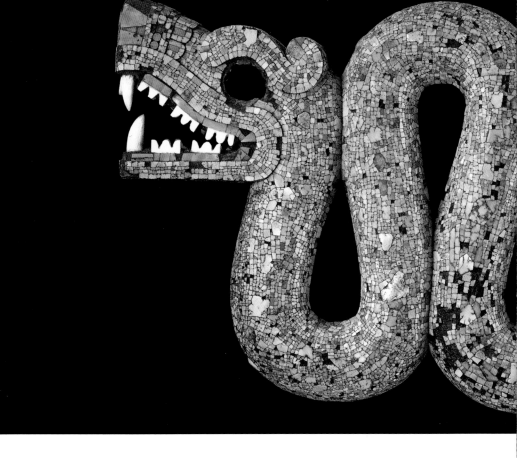

it was like the enchantments they tell of in the legend of Amadis, on account of the great towers and temples and buildings rising from the water, and all built of masonry. And some of our soldiers even asked whether the things they saw were not a dream.'

The theatrical entrance of Cortés and his armed men, with their horses and armour, along the southern causeway of the city rivalled the pomp and lavish display of power put on by Moctezuma. The semi-

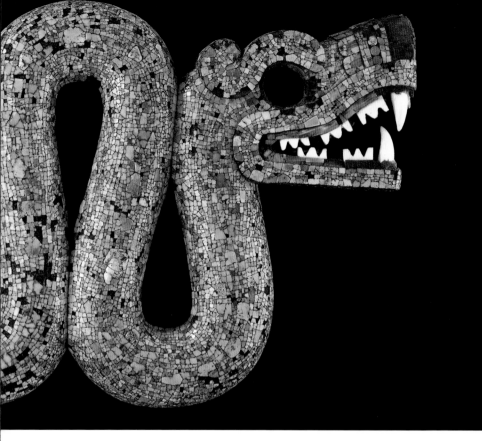

divine ruler was borne in his litter under a fabulous palanquin. Dressed in magnificent green feathers, lavish fabrics, glittering gold and turquoise ornaments he clearly displayed his status. As he dismounted and approached Cortés two high-ranking noblemen carried him by his arms. Gifts were ceremoniously exchanged: Cortés received an elaborate gold and greenstone necklace and in return he presented Moctezuma with Venetian glass beads strung on a golden filament.

This turquoise mosaic ornament is an example of the sort of gift that would have been given to Cortés and his men. Double-headed serpents were associated with Huitzilopochtli and were considered to be the bearers of bad omens.

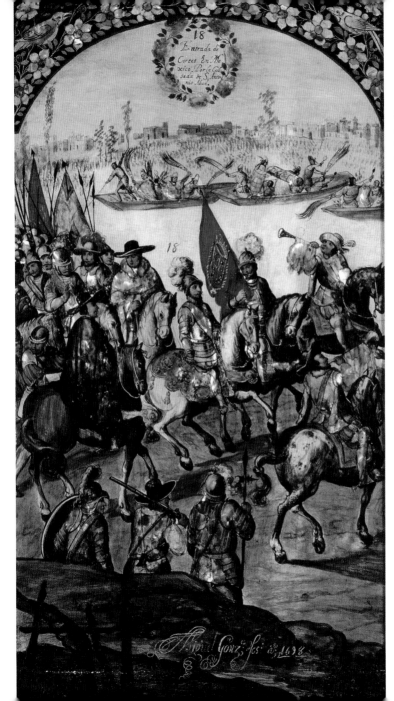

18

Entrada de
Cortés En Me
xico Por la Cal
sada de S. Anto
nio Abad.

18

Antonio Gonz. fec. á 1698

**ENCONCHADO
SERIES**

*c.*1680–1700,
oil on canvas
and shell.

Cortés approaches
Tenochtitlan. He
is accompanied
by fully armed
Spanish horsemen,
who carry flags and
lances, together
with foot soldiers.

Moctezuma
comes across
to meet Cortés.
He is borne on
the shoulders
of his two
noblemen under
a protective
awning.
His throne,
represented
in idealized
European form,
is carried
behind.
Attendants
lay capes and
mantles on
his path.

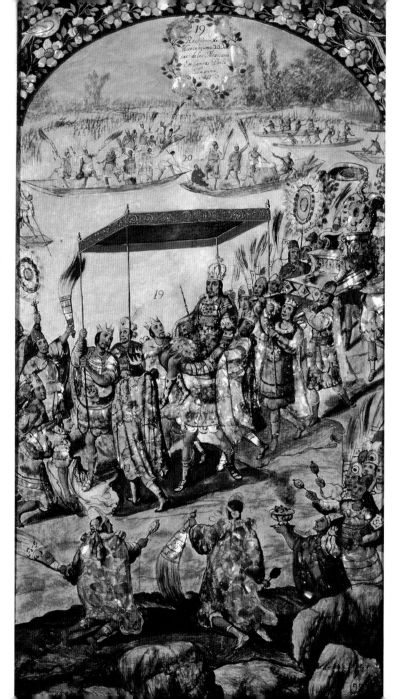

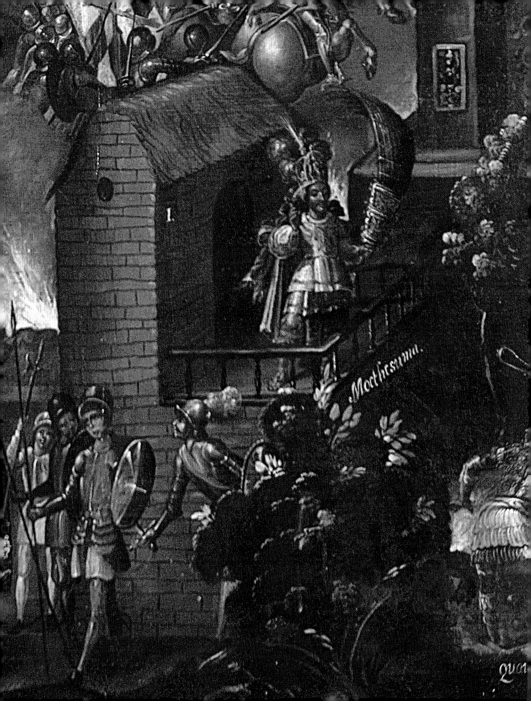

I.

Motheusuma.

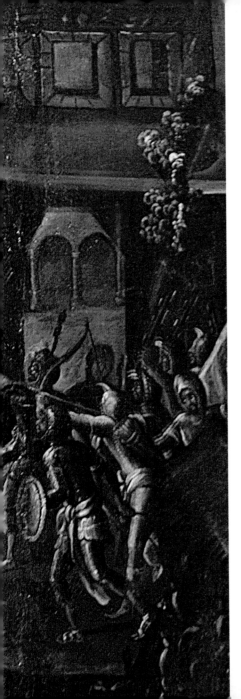

CAPTIVITY AND DEATH

Moctezuma housed the Spanish men and their Tlaxcalan allies in the palace of his father Axayacatl. Presents and ceremonial visits followed as part of the welcome to the strangers. The awe and fascination of the Spaniards soon gave way to the realization that they were in fact prisoners at the heart of the empire.

A powerful army was waiting to act upon Moctezuma's command, and this could have been fatal for the Spaniards. Cortés saw that the only way of escaping from that situation was to control the *tlatoani* himself. In a meeting between Cortés and Moctezuma that took place in the royal quarters, he did the unthinkable and took the great ruler hostage. Soon afterwards, Cortés demanded Moctezuma's submission to the king of Spain, Charles V.

Moctezuma was relocated to Axayacatl's palace with his servants, court and family, justifying the move as a sign of friendship between the Spaniards and the Mexica. Kept under close guard, he was allowed to attend to his affairs of state and preside over assemblies.

Moctezuma stands on a balcony in an effort to placate the enraged populace. Below him, a figure identified as Cuauhtemoc wields a sling that will deliver the fatal blow. Colonial painted screen, late 17th–early 18th century.

Moctezuma's intelligence, affable character and good manners captivated the Spanish soldiers. Among other entertainments he played board games with his captors and eventually went on hunting expeditions under close surveillance. It is unclear how much control he retained under the new regime, but the unease of his people was palpable throughout the city.

The situation changed rapidly during the forced absence of Cortés. Alvarado took command and made a fatal error. The annual festivities dedicated to Huitzilopochtli were taking place in the sacred precinct of Tenochtitlan. The highest members of Mexica nobility and the commanders of the army gathered fully dressed in their warrior attire to honour their tribal god. Alvarado led a cold-blooded attack and massacred most of the Mexica noblemen. Moctezuma never made his final appearance at the end of the rituals. Upon Cortés's return the city was ready to revolt against the outrageous behaviour of its guests, who had meddled in divine affairs.

As a desperate last resort, Cortés took Moctezuma out on to the palace balcony to speak to his people. The ruler had lost all authority, and colonial accounts describe how the angry crowd threw stones and spears at him. Some accounts report how he was injured with a blow to his head from which he died a few days later. Later sources even attribute this fatal shot to his nephew Cuauhtemoc. Other indigenous accounts imply a Spanish hand in getting rid of the now useless ruler before their desperate escape from the city during the *noche triste* (night of sorrows). The Spanish left behind many men, much of their gold treasure and a devastated empire. They had closed a chapter in Mexica history.

Below the temple in flames, where a Spanish soldier and a Mexica warrior fight, Moctezuma stands on the roof of a palace with a rope tied at his neck and led by his Spanish captor. In front of him lies an indigenous figure with a sword in his chest. The accompanying text seems to indicate that the figure is Moctezuma himself, possibly murdered by his captors.
Codex Moctezuma, late 16th–early 17th century, Mexica.

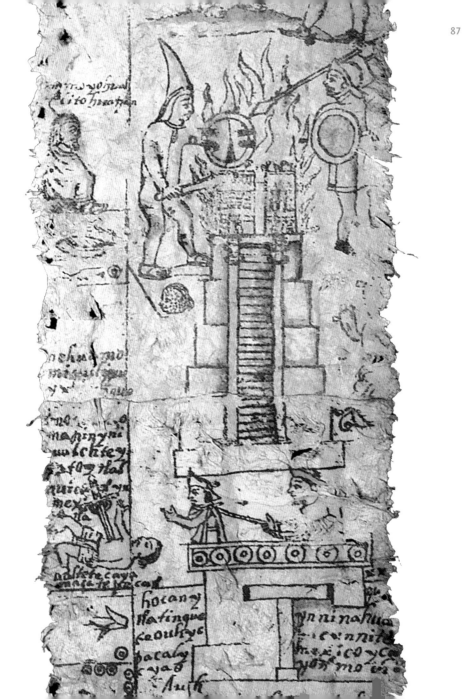

THE DISPOSAL OF THE BODY

The fate of Moctezuma's body remains an enigma. The bodies
of previous Mexica rulers had been prepared as funerary bundles
to be paraded on their litters in a well-orchestrated ceremony.
They were ritually cremated and their ashes were then buried with
the most elaborate offerings. These were usually interred in the
sacred precinct of Tenochtitlan in front of temples and under
commemorative monuments.

The Florentine Codex offers a visual and written version of
the disposal of Moctezuma's body. While the Spanish and Nahuatl
texts describe slightly different events, selectively omitting facts,
the images speak for themselves. The text mentions how four days
after the killing of the noblemen the inert body of Moctezuma, and
the body of the ruler of Tlatelolco, were found outside the palace. A
Spanish soldier and a nobleman are depicted throwing their bodies
into the canal. Their loyal followers later collected the bodies of their
deceased rulers. One of the bodies is gently laid on the ground, in
an image that recalls the Deposition of Christ in western imagery.

At this point in history Moctezuma was despised by many of
his own people, so no weeping subjects are depicted around his
funerary pyre. The pyre is improperly constructed in front of a
temple called 'Capulco', showing a simple shrine at the top, and his
body lies tossed among the wooden logs. However, Moctezuma
retained his turquoise crown and mantle, perhaps suggesting mixed
feelings about his status at the time of his death.

The disposal of
Moctezuma's body.
Florentine Codex,
book 12, fol. 40v.

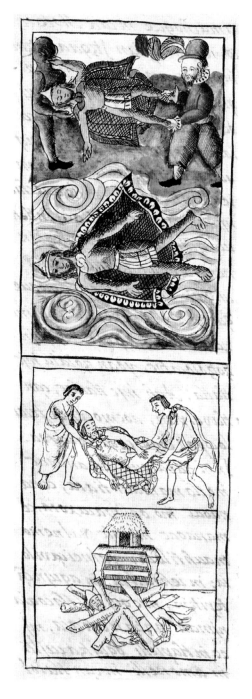

AFTERMATH

MOCTEZUMA's death and the conquest of his empire by the Spaniards put the Mexica people in the European spotlight. Their world had been turned upside down, and it was difficult to get used to the new reality.

Spanish ambition led to an obsessive search for gold, riches and fame. The indigenous people suffered exploitation under the new social and political order, and payment of taxes in the form of goods and labour was continuously demanded by the new colonial authorities. The Europeans brought with them an influx of diseases, such as smallpox and influenza, that ravaged most of the indigenous population. Demographics changed dramatically, and the land was redistributed in the interest of the newcomers. Long-established social relations were altered forever.

It was not only socio-economic and political governance that suffered violent change; a new religion was also imposed. Monotheism was forced on a world that had worshipped myriad gods over the centuries. However, Mexica people were used to incorporating foreign deities into their pantheon, and they took on the new Catholic faith without giving up their ancestral beliefs. Underlying the official Catholic practices, the religion of the Mexica past was still alive, creating a new merged world of beliefs.

Soon after Moctezuma's death, Mexica history, and the events of the conquest, were rewritten according to the truth as espoused by various different groups. Moctezuma's figure was reappraised in Europe and in Mexico following highly politicized agendas. Seen as a tragic hero and a valiant ruler of a vanished empire, Moctezuma's figure was idealized and reshaped to fit with Western political needs. Meanwhile, in Mexico, his name was associated with treason and defeat.

This legal document was painted by *tlacuiloque* (artist-scribes) in the indigenous tradition, accompanied by commentaries in Spanish. European influences are visible in the painting style. The codex denounces the excessive tribute demanded by the Spanish and the ill treatment of the indigenous people. Codex Tepetlaoztoc, 1554.

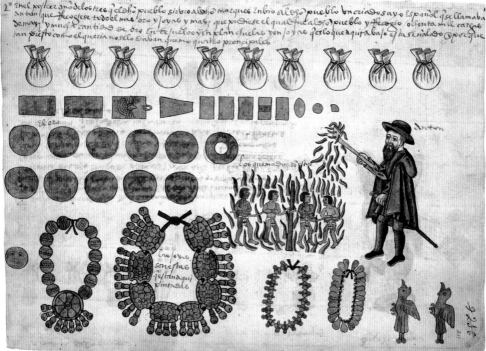

However, Moctezuma's descendants soon positioned themselves in the new colonial order. Doña Isabel Moctezuma, the favourite daughter of the Mexica ruler, had a daughter by Cortés. Moctezuma's granddaughter would marry a Spanish nobleman and settle in the Castilian city of Caceres. Moctezuma's lineage became associated with Spanish nobility as his fame grew in the European collective imagination.

Today, the legacy of Moctezuma's empire is still alive in Mexico, blending the past into the present and creating its unique identity. Moctezuma's rulership was less the end of an era than a crucial part of Mexican history, a history that is still being written today.

During the second half of the sixteenth century the head of this Mexica plumed serpent was removed. The deity was literally decapitated, the sculpture inverted and a cavity drilled in its underside to be used as a baptismal font. The merging of religions and the turning upside down of the Mexica world order are graphically expressed in this object.

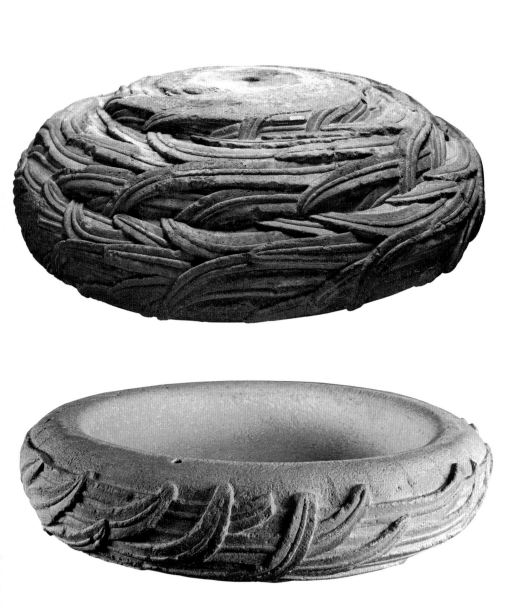

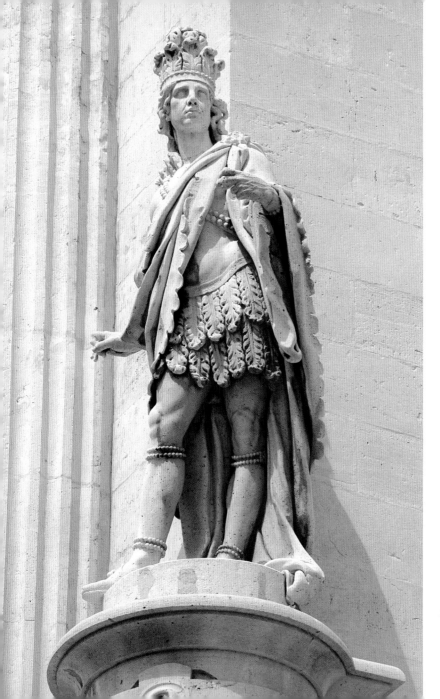

Sculpture of
Moctezuma II,
Palacio Real,
Madrid.

Further reading

Gordon Brotherston, *Painted Books from Mexico: Codices in the UK Collections and the World they Represent*, London 1995

Bernal Díaz del Castillo, *The Conquest of New Spain*, J.M. Cohen (trans. and ed.), Harmondsworth 1963

The Codex Mendoza, facsimile edition, Frances F. Berdan and Patricia Rieff Anawalt (eds), 4 vols, Berkeley 1992

Diego Durán, *The History of the Indies of New Spain*, Doris Heyden (trans.), Norman 1992

Serge Gruzinski, *Painting the Conquest. The Mexican Indians and the European Renaissance*, Deke Dusinberre (trans.), Paris 1992

Leonardo López Luján, *The Offerings of the Templo Mayor of Tenochtitlan*, revised edition, Albuquerque 2005

Colin McEwan, *Ancient Mexico in the British Museum*, London 1994

Colin McEwan, *Ancient American Art in Detail*, London 2009

Colin McEwan and Leonardo López Luján (eds), *Moctezuma: Aztec Ruler*, exh. cat., British Museum, London 2009

Colin McEwan, Andrew Middleton, Caroline Cartwright and Rebecca Stacey, *Turquoise Mosaics from Mexico*, London 2006

Eduardo Matos Moctezuma, *The Great Temple of the Aztecs*, London and New York 1988

Eduardo Matos Moctezuma and Felipe Solís Olguín (eds), *Aztecs*, exh. cat., Royal Academy of Arts, London 2002

Esther Pasztory, *Aztec Art*, New York 1983

Bernardino Sahagún, *Historia General de las Cosas de Nueva España*, 9th edition, Mexico City 1997

Michael E. Smith, *The Aztecs*, 2nd edition, Oxford 2003

Jacques Soustelle, *The Daily Life of the Aztecs on the Eve of the Spanish Conquest*, Patrick O'Brian (trans.), London 1961

Richard F. Townsend, *The Aztecs*, revised edition, London and New York 2000

Illustration acknowledgements